THE KINGS AND QUEENS
OF ENGLAND

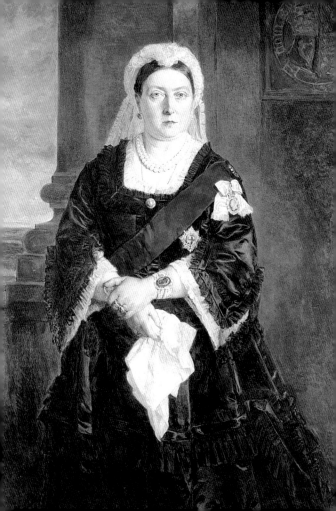

THE KINGS AND QUEENS OF ENGLAND

Text by
Nicholas Best

Portraits courtesy of
the National Portrait Gallery, London

WEIDENFELD & NICOLSON
LONDON

Text © 1995 Weidenfeld & Nicolson

All illustrations © 1995 National Portrait Gallery, London
Elizabeth II, By courtesy of the National Portrait Gallery,
London/Michael Leonard.

First published in 1995 by
George Weidenfeld & Nicolson Limited
The Orion Publishing Group
Orion House
5 Upper St Martin's Lane
London WC2H 9EA

British Library Cataloguing-in-Publication Data
A record for this book is available from the British Library

ISBN 0 297 83487 8

Printed and bound in Italy

FRONT COVER
Henry VIII (detail) after Hans Holbein, *c.*1536.

BACK COVER
Elizabeth I (detail) by or after George Gower, *c.*1588.

FRONTISPIECE
Victoria (detail) by Lady Julia Abercromby after Heinrich von
Angeli, 1875.

CONTENTS

THE NORMANS

THE ANGEVINS

THE PLANTAGENETS

THE HOUSE OF LANCASTER

THE HOUSE OF YORK

THE TUDORS

THE STUARTS

—— CONTENTS ——

THE HOUSE OF HANOVER

THE HOUSE OF
SAXE-COBURG-GOTHA

THE HOUSE OF WINDSOR

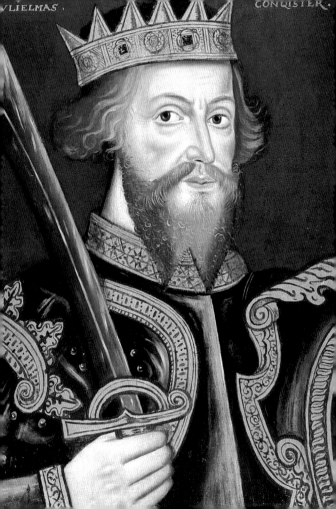

WILLIAM I

Born around 1028, William was the illegitimate son of the Duke of Normandy and a second cousin of Edward the Confessor. When Edward died childless, the English crown was offered to Harold Godwinson, although it had previously been promised to William. Feeling cheated, he led a Norman army across the Channel and defeated Harold at Hastings in 1066.

William was a powerful man who had grown up fearing for his life and trusting no one. He imposed a harsh rule on the English, introducing the feudal system and listing the nation's wealth in the Domesday Book so that he could tax it heavily. He was merciless to anyone who stood in his way. But he was also a fine administrator who reintroduced law and order to a land that had been in chaos for centuries. Feared rather than loved, he left the country in very good shape when he died in 1087.

Called William I (detail) by an unknown artist.

WILLIAM II

reigned 1087-1100

William was born about 1057, the second surviving son of William I. As was customary, he inherited the conquered lands (England) on his father's death in 1087, while his elder brother Robert inherited Normandy. The two of them quarrelled over the spoils until 1096, when Robert pawned Normandy to William and went to the Holy Land on a crusade.

William was a hard, tough man, very like his father. He was nicknamed Rufus because of his red hair. He had little time for religion and confiscated much Church property for his own ends. Since history at that time was largely written by monks, his reputation has suffered accordingly. He died in 1100, while out hunting in the New Forest. He was fatally hit by an arrow and nobody has ever known whether it was an accident or murder.

William II (detail) by M. Van de Gucht.

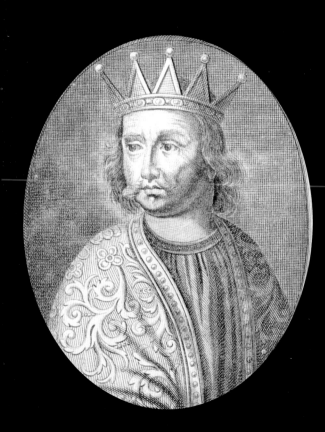

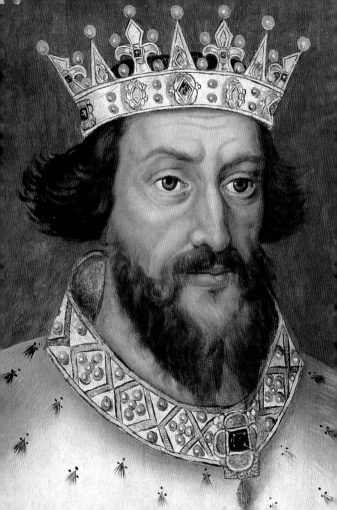

HENRY I

reigned 1100-1135

Henry, born in 1068, was the fourth and ablest son of William the Conqueror. He inherited the crown on William's death in 1100, but was challenged for it by his older brother Robert of Normandy. They fought at the battle of Tinchebrai in 1106, where Henry defeated Robert and held him prisoner for the rest of his life.

Having secured his throne, Henry concentrated on home affairs, wooing the Church, improving the administration of government and organizing the beginnings of the modern legal system. An uncompromising ruler – he once pushed a man off the top of Rouen Castle for breaking an oath of allegiance – he was also recognized as a fair one. His only legitimate son drowned in the 'White Ship' in 1120. Henry died fifteen years later, leaving behind a country that had been at peace for more than thirty years – remarkable, by the standards of the time.

Called Henry I (detail) by an unknown artist.

STEPHEN

reigned 1135-1154

Born around 1096, Stephen was a grand-son of William the Conqueror by his daughter Adela. After Henry I's death in 1135, the crown should have gone to Henry's daughter Matilda. But the Council decided in favour of Stephen, as a man, thus setting the scene for a generation of civil war.

Matilda invaded England in 1139, establishing an alternative court in the West Country. Stephen was too weak to stop her and stalemate ensued. The barons supported first one side, then the other, and were mostly a law unto themselves. After many years of attrition a compromise was finally agreed, whereby Matilda's son Henry would inherit the throne after Stephen's death. He duly died in 1154, much liked as a man, but not greatly admired as a king.

Called Stephen (detail) by an unknown artist.

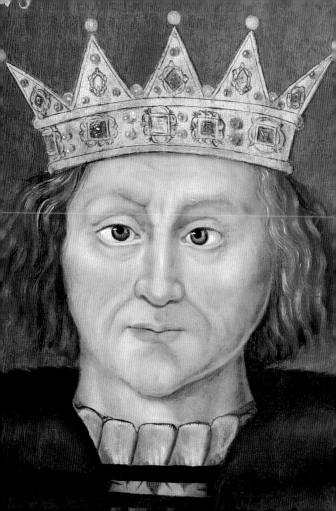

HENRY II

hrough both marriage and inheritance, Henry (born 1133) acquired an empire stretching from the Somme to the Pyrenees, and from the Scottish border almost to the Mediterranean. To this he added Ireland, a task entrusted to him by the only Englishman ever to become Pope. But his main aim was to curb the barons and the Church, both of whom had become too powerful under King Stephen.

He succeeded in defeating the barons, pulling down their castles, reforming the system of taxation and introducing the rudiments of trial by jury. But he never defeated the Church and had to take the blame for the murder of Thomas à Becket at Canterbury. He was a strong, energetic king, full of good sense, yet he died unhappily in 1189, knowing that his subjects were in rebellion and even his own sons were plotting against him.

Called Henry II (detail) by an uknown artist.

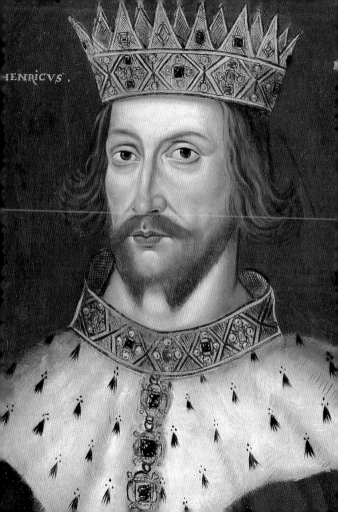
HENRICVS.

RICHARD I

reigned 1189-1199

As Henry II's eldest son, Richard the Lion-heart (born 1157) became king in 1189 and promptly set out for the Holy Land to join the Third Crusade. Failing to conquer Jerusalem, he was captured on the way home and held to ransom for more than a year by the Emperor Henry VI. Legend has it that he was finally tracked down by his minstrel, Blondel, singing outside his castle window.

While Richard was in prison, his brother John had ceded territory to Philip of France. On his release, Richard entrusted the government of England to the Archbishop of Canterbury rather than his brother, and devoted the next five years to recovering his French possessions. He was still trying to get them back when he died of wounds in 1199. Richard was an outstanding soldier, but spent less than a year in England during his entire reign.

Richard I (detail) by Proud after an unknown artist.

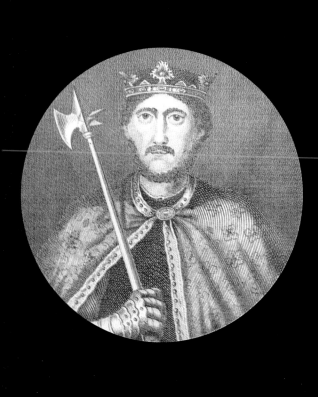

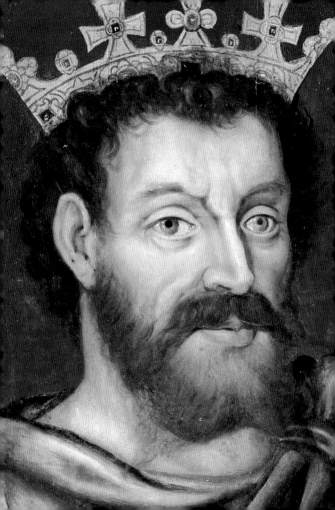

JOHN

— ❖ —

reigned 1199-1216

John (born 1167) was Henry II's youngest son, a thoroughly unpleasant character, disliked and distrusted by everyone. He succeeded in 1199, but some of his French subjects refused to recognize him, preferring his twelve-year-old nephew Arthur. John captured Arthur, who was never seen again, and set about raising the money needed to regain his French possessions.

This brought him into conflict with the barons, protesting at the high level of taxation. He also quarrelled with the Church, and alienated ordinary people with his bad government. Eventually the barons forced him to sign a bill of human rights – Magna Carta – at Runneymede in 1215. John promptly reneged on the agreement, forcing the barons to seek help from France. He died a year later, leaving the country in a state of near anarchy.

Called John (detail) by an unknown artist.

HENRY III

reigned 1216-1272

Henry was only nine when he succeeded his father in 1216. The country was well governed until he took control himself in 1227. Thereafter he alienated his subjects, just as his father had done, by raising heavy taxes to spend on useless wars. His court was dominated by Frenchmen, many related to his wife, who grabbed the most profitable jobs for themselves.

Opposition was organized by his brother-in-law, Simon de Montfort, who took Henry prisoner in 1264 and forced him to summon a parlement (French for speaking), composed of representatives from every shire. De Montfort was killed in 1265, but the idea of a Parliament survived. Henry lingered on until 1272. He had been weak and unreliable as a king, but left a fine legacy in the rebuilding of Westminster Abbey and the remodelling of several cathedrals.

Called Henry III (detail) by an unknown artist.

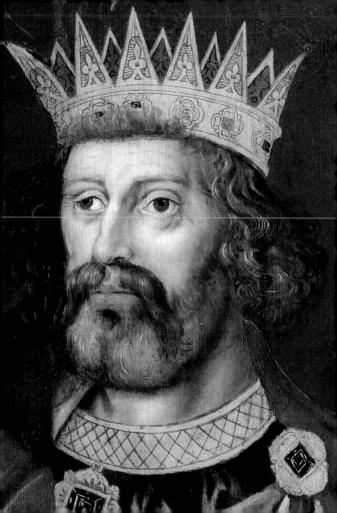

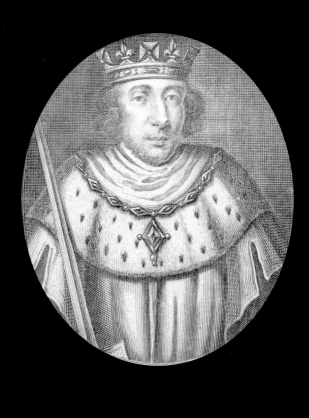

EDWARD I

reigned 1272-1307

Born in 1239, Edward was already king in all but name when his father died in 1272. He had defeated Simon de Montfort on Henry's behalf and displayed all the strength and decisiveness his father lacked. It was during Edward's reign that Parliament met regularly for the first time and became the accepted way of conducting public business.

Edward was a great reformer – he revised the legal system, making laws subject to Parliament – and was also a good soldier. He never achieved his aim of unifying the whole island under his rule, but he did make his son Prince of Wales, and he fought the Scots so hard that he earned the nickname 'Hammer of the Scots'. Unfortunately, he also expelled the Jews (seen then as killers of Christ) from England. It was more than 300 years before they were allowed to return. Edward died in 1307.

Edward I (detail) by George Vertue after an unknown artist.

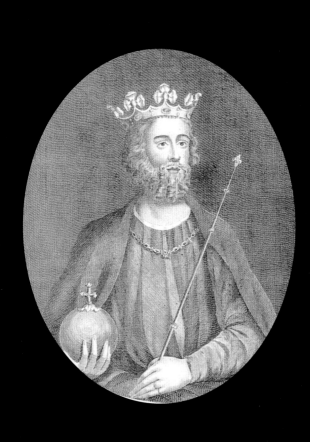

EDWARD II

✤

reigned 1307-1327

Few kings have been sillier or less suited to the throne than Edward. Born in 1284, he always preferred the company of workmen to courtiers and was not in the least interested in statecraft or the responsibilities of kingship. It was a disaster for the country when he succeeded to the throne in 1307.

Although married to Isabella of France, Edward spent far more time with his handsome friend Piers Gaveston, a French adventurer who milked the royal connection for all it was worth. But rival barons executed Gaveston and his successor as royal favourite, Hugh Despenser. Matters eventually came to such a pass that Isabella and her lover Roger Mortimer imprisoned Edward in Berkeley Castle. He was murdered there in 1327 – skewered with a red-hot spitting iron – and his son was declared king in his place.

Edward II (detail) by Goldar after a tomb at Gloucester.

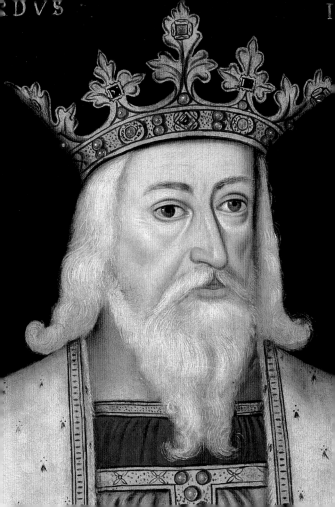

EDWARD III

reigned 1327-1377

Edward was fourteen in 1327. For the first three years of his reign, England was ruled by his father's murderer, Mortimer. But Edward had Mortimer executed in 1330 and took control himself. He was the opposite of his father – a formidable young man who greatly impressed the barons on whose support he depended.

The way to keep them happy was to organize a war. So Edward pursued his claim to the French throne, winning in 1346 the Battle of Crècy – where English archers showed their skills for the first time – and provoking the Hundred Years War. But the English were never able to hold on to their gains, particularly after the arrival of the Black Death (bubonic plague), which killed at least a third of the population. Edward survived until 1377, long enough to see his best efforts frustrated through little fault of his own.

Edward III (detail) by an uknown artist.

RICHARD II

⟡

reigned 1377-1399

Edward III's son the Black Prince prede-
ceased his father, so it was Edward's
grandson Richard who succeeded in
1377, aged ten. The Peasants' Revolt
followed four years later. Prices had risen
sharply because of the Black Death, but wages
had not risen in line. Richard faced down a hos-
tile mob whose leader Wat Tyler was killed.

But though he was brave, Richard did not
inspire his people. He was arrogant and untrust-
worthy, sitting haughtily on his throne and forc-
ing people to kneel if they caught his eye. His
biggest mistake was to try and rule without Par-
liament. He abused his powers so arbitrarily that
eventually the barons had to act in self-protection.
Richard's cousin Henry of Lancaster seized the
crown in 1399 and a year later Richard was mur-
dered in Pontefract Castle – the first casualty of
the Wars of the Roses.

Richard II (detail) by an unknown artist.

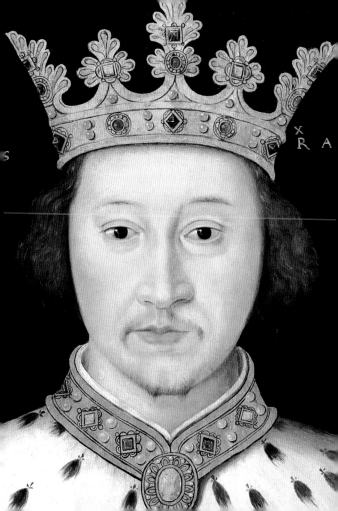

HENRY IV

reigned 1399-1413

Although he was Edward III's grandson, there were others who had a better claim to the throne than Henry. He was thirty-three when he seized the crown in 1399, and he spent much of his reign struggling to hold on to it.

Richard II's family immediately rose against him, as did Owen Glendower in Wales and his powerful allies Mortimer and Percy. Henry responded by putting Richard's body on public display, to show that he was dead, and by chopping up his enemies and carting their bodies to London in sacks. By 1410 he had succeeded in quelling the opposition, but was desperately short of money – and kept so by Parliament. Henry had always wanted to die in Jerusalem on a crusade. In the event, he died in 1413, probably of leprosy, in the Jerusalem chamber of Westminster Abbey.

Called Henry IV (detail) by an unknown artist.

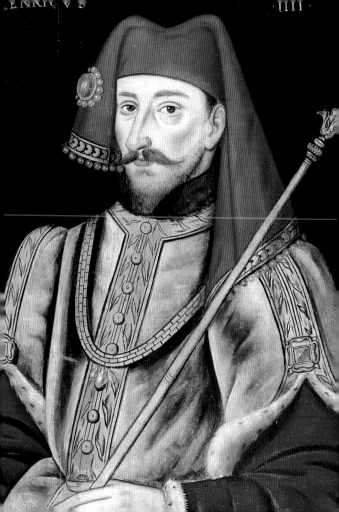

HENRY V

❖

reigned 1413-1422

Henry was an outstanding king, duly celebrated in one of Shakespeare's most famous plays. He was only twenty-six when his father died in 1413, but he had already proved himself as a soldier in a long campaign against the Welsh. In 1415 he turned his attention to France, besieging Harfleur and destroying the finest French chivalry at Agincourt. By 1420 he had married the king's daughter and forced him to recognize Henry as heir to the French throne, in place of his own son.

At home too he was a shrewd politician and fine administrator. He was greatly admired for his piety and hard work. Unfortunately, he died of dysentery in 1422, leaving a son just nine months old to inherit the thrones of both England and France. It was a thankless inheritance for anyone in troubled times, let alone a child.

Henry V (detail) by an uknown artist.

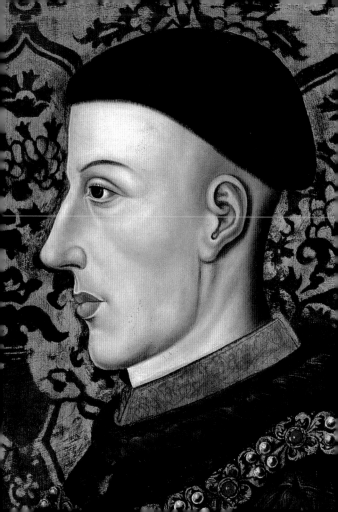

HENRY VI

reigned 1422-1471

orn in 1421, king from 1422, Henry grew up deeply religious and not in the least warlike. He was a kind, gentle man, terrified of girls. He once saw the body of a traitor, quartered on a stake, and ordered that nobody was ever to be treated like that again in his name.

But Henry was far too feeble to be a king. His French grandfather had been mentally ill, and so was Henry from 1454. The French refused to accept him as their monarch. In England, the Duke of York claimed the crown for himself in 1455. The worst of the Wars of the Roses followed, during which Henry saw frequent periods of captivity. His people looked to him for leadership, but were always disappointed. He was finally murdered by York's son in 1471, leaving behind Eton College and King's College, Cambridge as his only memorials.

Henry VI (detail) by an unknown artist.

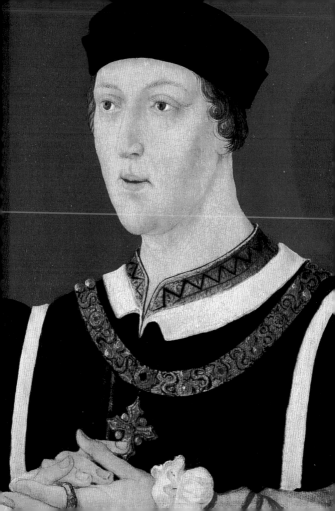

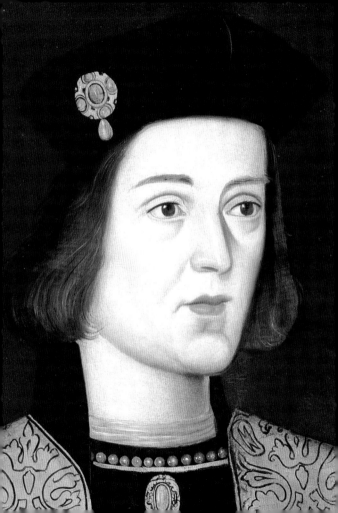

EDWARD IV

reigned 1461-1483

Edward was born in 1442, the son of the Duke of York. His father led the Yorkists in the Wars of the Roses, but was killed in 1460. Edward was crowned a year later, although Henry VI was still alive. But Henry was murdered at the Tower of London in 1471 and Edward ruled undisputed thereafter.

He was a good soldier and a strong king. His chief ally in the early years was the Earl of Warwick (the 'Kingmaker'), who later turned against him. Edward defeated Warwick and also his own brother, the Duke of Clarence, allegedly drowned in a butt of Malmsey. During the latter part of his reign, he took a great interest in William Caxton, who had introduced printing to England. Edward died in 1483, leaving two sons aged nine and twelve in the care of his brother Richard, Duke of Gloucester.

Edward IV (detail) by an unknown artist.

EDWARD V

No king ever had a more tragic reign than Edward. He was twelve when his father died in 1483. His Lancastrian mother immediately summoned him to London, in order to protect him from his father's Yorkist brother, Richard, Duke of Gloucester. However, Richard captured Edward on the road and imprisoned him in the Tower of London.

His younger brother followed, and the two were held captive while Richard decided what to do with them. His own position would be threatened if he let them go. Nobody has ever proved that he had them killed, but there is strong evidence that he did. The two princes disappeared in the autumn of 1483 and were never seen again. Their skeletons were discovered in 1674, during rebuilding work at the Tower, and are now buried in Westminster Abbey.

Called Edward V (detail) by an uknown artist.

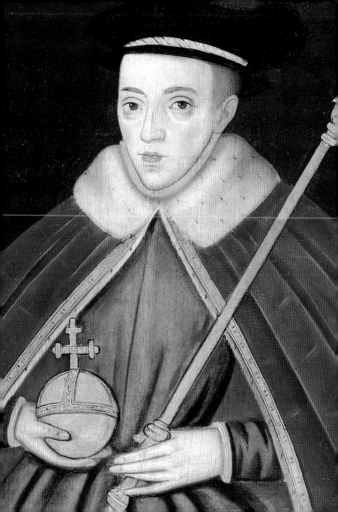

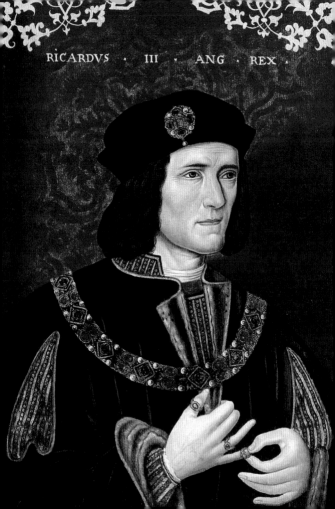
RICARDVS · III · ANG · REX ·

RICHARD III

reigned 1483-1485

Richard might have been a good king if it wasn't for the princes in the Tower. Born in 1452, he was a brave soldier, an able administrator and a happy family man, much respected on his home territory in the north of England. But the murder of the two princes in 1483, and Richard's seizure of the crown for himself, ensured that his was one of the shortest reigns in English history.

The princes' mother immediately offered their sister Elizabeth as a wife to Henry Tudor, an exiled Lancastrian of illegitimate royal blood. Henry accepted and invaded England in 1485. Richard was so unpopular by then that some of his allies simply stood and watched as he charged to his death at the battle of Bosworth. His naked body was slung over a horse and displayed in Leicester for two days, after which it was buried in an unmarked grave.

Richard III by an unknown artist.

HENRY VII

reigned 1485-1509

ly, crafty and highly intelligent, Henry was born in 1457, the son of an obscure Welsh nobleman. On his mother's side he was descended from Edward III and became leader of the Lancastrian party after the other claimants to the throne had been killed. A poor soldier, he was lucky to have defeated Richard III at Bosworth in 1485.

He was also the last monarch to seize the crown by force. By marrying Elizabeth of York (the queen depicted on playing cards), he brought the Wars of the Roses to an end and secured a lasting peace. He taxed the nobility so heavily that they were unable to cause trouble, and encouraged trade with Europe as well as financing the discovery of Newfoundland and Nova Scotia. He died in 1509, leaving the country stable and prosperous for the first time in 100 years.

Henry VII (detail) by Michiel Sittow, 1505.

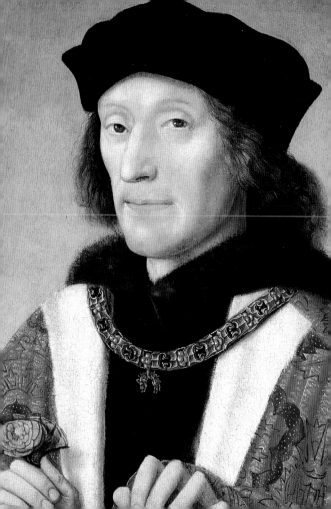

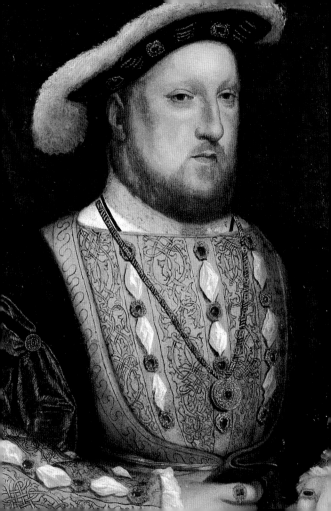

HENRY VIII

reigned 1509-1547

Despite his savage reputation – he divorced two of his six wives and beheaded another two, as well as countless of his subjects – Henry was actually an outstanding ruler. He was born in 1491 and succeeded his father at seventeen. He was handsome, clever and naturally authoritative, and for the next thirty-eight years he dominated the kingdom as few monarchs have done either before or since.

Perhaps his most notable achievement was to break with the Church of Rome, making England the first of many countries to go their own way under a Protestant crown. But he also presided over a great increase in prosperity, at a time when much of Europe was in religious and political turmoil. And he did it without a standing army, which is arguably the greatest feat of all. The country felt an enormous loss when he died in 1547.

Henry VIII after Hans Holbein, c.1536.

EDWARD VI

reigned 1547-1553

Edward's birth in 1537 was a triumph for his father. After twenty-eight years as king – and three wives, the last of whom, Jane Seymour, died after giving birth to Edward – Henry VIII finally had a male heir. He saw to it that from the first Edward was brought up to be a king.

But Henry died in 1547, when Edward was only nine. Edward's 'Protectors' – first the Duke of Somerset, then the Duke of Northumberland – ruled in his name. They promoted Protestantism as the established religion and introduced Cranmer's Book of Common Prayer. But they also mismanaged the economy and alienated large sections of the community. Edward himself, ill with consumption (tuberculosis), was too weak to intervene. He died in 1553, naming as heir his Protestant cousin Lady Jane Grey, rather than his Catholic half-sister Mary.

Edward VI (detail) by an unknown artist.

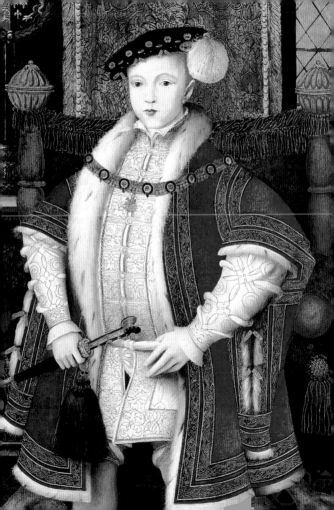

MARY I

Mary was born in 1516, the eldest child of Henry VIII. Her maternal grandfather was king of Spain and throughout her life Mary was a devout Catholic. She became queen in 1553, after a nine-day reign by her cousin Lady Jane Grey ended in disaster (Jane was ultimately beheaded).

Mary was the legitimate heir, but the mood of her people was for Protestantism. She surrounded herself with Catholic advisers and in July 1554 married Philip, heir to the Spanish throne. But the marriage was unhappy and not accepted by Parliament. Mary blamed her failures on divine retribution for allowing heresy to thrive in England. She tried to atone by burning hundreds of Protestants at the stake, including bishops Cranmer, Ridley and Latimer at Oxford. She died unlamented in 1558, known to everyone as 'Bloody Mary'.

Mary I (detail) by Hans Eworth, 1554.

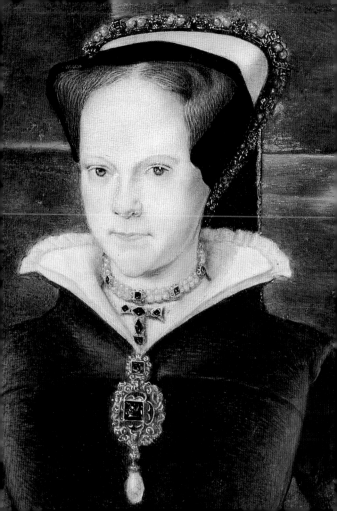

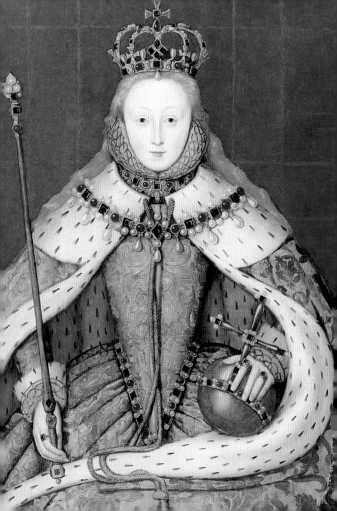

ELIZABETH I

reigned 1558-1603

'I know I have but the body of a weak and feeble woman,' Elizabeth told her troops, on the eve of the Spanish armada, 'but I have the heart and stomach of a king.' As the daughter of Henry VIII, she ruled very much in her father's image from 1558 to 1603. But the price she paid in personal happiness was a heavy one.

She was born in 1533, the daughter of Henry's second wife Anne Boleyn. Her mother was executed when Elizabeth was two and she spent much of her childhood a virtual prisoner, trusting no one. The kingdom she inherited from her half-sister Mary was deeply divided by religious differences, which Elizabeth made it her life's work to reconcile. That she largely succeeded, as well as presiding over a golden age of literature and exploration, is a tribute to a great queen and a remarkable, if lonely, woman.

Elizabeth I (detail) by an unknown artist.

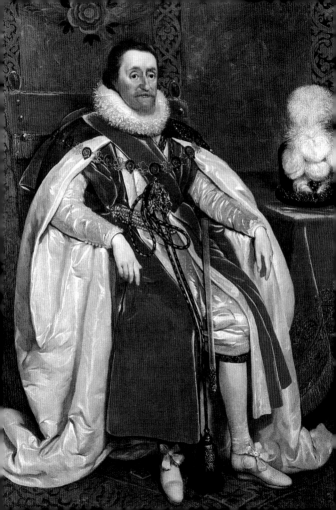

JAMES I

reigned 1603-1625

Descended from Henry VII, James VI of Scotland became James I of England when his cousin Elizabeth died in 1603. He was born in 1566, three months after his mother Mary, Queen of Scots, had seen her Italian musician Riccio stabbed to death at dinner. His father, Lord Darnley, was murdered a few months later, and after he was a year old James never saw his mother again.

He grew up believing that kings were appointed by God and had a divine right to rule. This brought him into conflict with the English Parliament, which distrusted his judgment on a variety of issues. Guy Fawkes (a Catholic) tried to blow them all up in the Gunpowder Plot of 1605. James authorized the translation of the Bible into English in 1611, and nine years later the Mayflower pilgrims left for America. James died in 1625.

James I by Daniel Mytens, 1621.

CHARLES I

reigned 1625-1649

Born in 1600, Charles became king in 1625 and promptly clashed with Parliament over which of them was in charge of the country. Charles believed in the divine right of kings, Parliament in a constitutional monarchy. The result was disastrous for everyone.

For eleven years Charles tried to rule without a Parliament at all, alienating the country with the taxes he imposed illegally. When Parliament reassembled, he tried to arrest five of his opponents in the Commons. Civil War followed, and the Royalists were beaten. Charles was offered an honourable peace, but he tried to start the war again. Exasperated, the Parliamentarians put him on trial for waging war on his own people. He was found guilty by one vote and publicly executed in 1649. England was a republic for the next eleven years, under the leadership of Oliver Cromwell.

Charles I by Daniel Mytens, 1631.

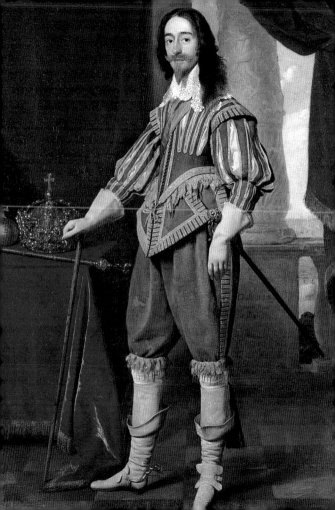

CHARLES II

reigned 1660-1685

liver Cromwell's death left a void in English life which only a monarch could fill. In 1660 Charles II returned from exile and was joyfully received in London. He was given his father's crown back, on the understanding that he would never behave towards Parliament as his father had done.

Charles was careful to learn from his father's mistakes. Born in 1630, he had been involved in the Civil War from the age of twelve and had had a very insecure childhood. Once king, he took care to reconcile his enemies and promote a policy of toleration (with a secret Catholic bias). He also enjoyed himself to the full, fathering children on numerous mistresses, including Nell Gwynne. The Great Plague ravaged London during his reign, followed a year later by the Great Fire. Charles died in 1685, much loved by ordinary people as a 'Merry Monarch'.

Charles II (detail), Studio of J. M. Wright, c.1660-5.

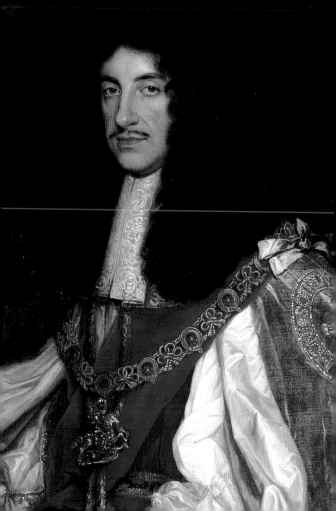

JAMES II

Unlike his brother, James (born 1633) never made any secret of his Catholicism. So when Charles died in 1685, James found himself king of a fiercely Protestant country in which Catholics were forbidden to hold any public office. It was a recipe for constitutional disaster.

Charles's illegitimate son the Duke of Monmouth immediately led a rebellion against James. Monmouth was executed and the rebels severely punished at the Bloody Assizes. People gave James their loyal support until he went too far – first by allowing Catholic officers in the army, then by putting seven Protestant bishops on trial for sedition. In 1688 William of Orange, James's son-in-law, was invited to rule in his place. James was exiled to France, where he died in 1701. The Glorious Revolution was achieved without a drop of blood being spilt.

James II (detail) by Sir Godfrey Kneller, 1684-5.

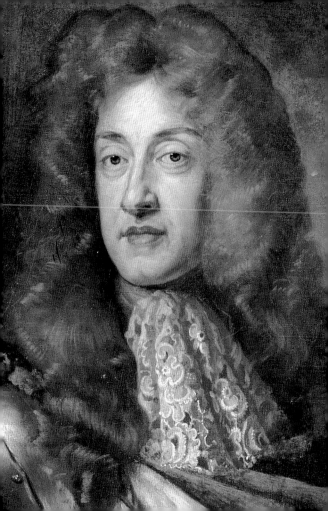

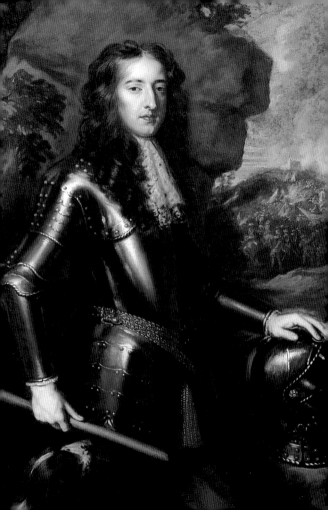

WILLIAM III

reigned 1688-1702

William of Orange (born 1650) was a Dutch Protestant, a grandson of Charles I. He married his cousin Mary (born 1662), the eldest daughter and heir of James II. When James's Catholicism became too much for the English in 1688, Parliament invited William and Mary to rule as a pair in his place. They accepted by constitutional agreement, rather than divine right.

James invaded Catholic Ireland, to try and win his throne back, but was decisively beaten by William at the Boyne in 1690. Mary died in 1694, and William devoted the rest of his reign to fighting the French in Europe. He was respected by his subjects, but not particularly liked. When he died in 1702, after his horse slipped on a mole hill, Jacobites everywhere raised their glasses 'to the little gentleman in black velvet'.

William III after Sir Peter Lely, after 1677.

MARY II

—— ✥ ——

reigned 1688-1694

Born into a man's world, Mary grew up meek and mild, only too happy to leave the politics to her father first, and later to her husband. She wept for days when James told her, aged fifteen, that she was to marry the hunchbacked William. But she later became reconciled to the marriage, although William never treated her as well as he should have done.

Mary greatly resented being forced to accept the throne in place of the father she loved (and never saw again). For political reasons, she also became estranged from her sister Anne, sometimes cutting her dead in the park. With no children of her own, she depended on her unfaithful husband for everything. Hers was not a particularly happy life, but she was a decent woman and was genuinely mourned when she died at the age of thirty-two.

Mary II (detail) by Sir Peter Lely.

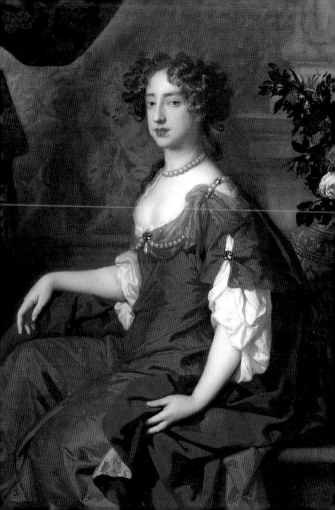

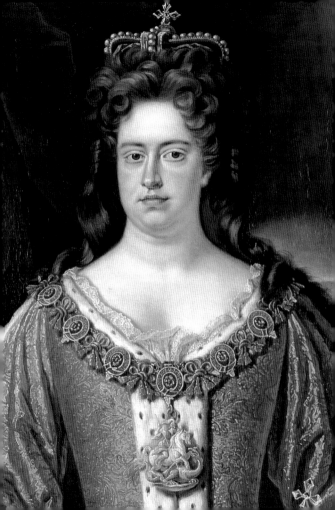

ANNE

❖

Anne was born in 1665, the second daughter of James II. After her sister Mary's death in 1694, she allowed William to remain as king, although she was the rightful heir. She did not become queen herself until 1702.

Anne was the last of the Stuart monarchs. She had seventeen children by George of Denmark, but not one of them survived her. She enjoyed a close friendship with Sarah Churchill, whose husband she made Duke of Marlborough. But the women later quarrelled and Marlborough was dismissed from command of the army, even though he had won a series of famous victories in the War of the Spanish Succession. Anne's reign was notable for the emergence of the two-party political system and the union with Scotland in 1707. She died in 1714, exhausted by the cares of state, for which she had no particular aptitude or enthusiasm.

Anne (detail), Studio of John Closterman, c.1702.

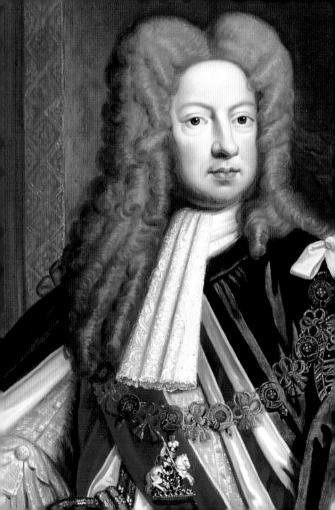

GEORGE I

reigned 1714-1727

George began life as a minor German noble and ended it king of England. He was born in 1660, a great grandson of James I, and became king in 1714, after Queen Anne had died without an heir. He never learned English and was never happy in England, always preferring his beloved Hanover.

George kept his wife Sophia in prison for thirty-two years, on suspicion of adultery with the Swede Philip von Königsmark. Königsmark himself was never seen again, and it was widely believed that his mutilated body lay beneath the floorboards of George's Hanover palace. Not surprisingly, the English never took to their new monarch. It was during his reign that Sir Robert Walpole became the first 'prime' minister, filling the role at council meetings that George, with his poor grasp of English, could not. He died unmourned in 1727.

George I (detail), Studio of Sir Godfrey Kneller, c.1714.

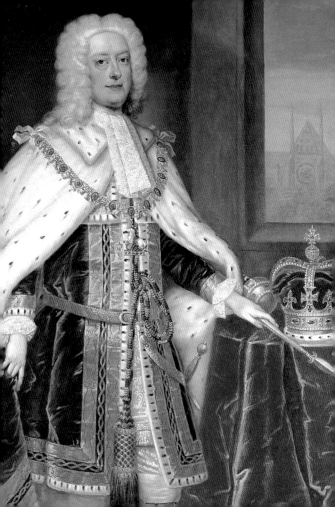

GEORGE II

reigned 1727-1760

B orn in 1683, George grew up in Hanover and was only English by adoption. He and his father always loathed each other. The younger George once tried to swim a castle moat in a vain attempt to see his mother, imprisoned by his father for adultery.

He became king in 1727, having refused to speak to his father for years at a time. As a young man, he had fought at Oudenarde in 1708. As an old man, he became the last English sovereign to lead troops into battle, at Dettingen in 1743. Despite his courage, however, George never won the affection of his people. He was arrogant, pompous and boring, an object of derision for much of his life. He died in 1760, a martyr to constipation, on the lavatory. It was considered a fitting end for a faintly ludicrous king.

George II (detail), Studio of Charles Jervas, c.1727.

GEORGE III

❖

reigned 1760-1820

George III was the grandson of George II. Born in 1738, he grew up in England and was the first Hanoverian king to speak without a foreign accent. He was a decent conscientious man, who would have been happier as a farmer than a king. Loathing the corruption of party politics, he did all he could to recapture power for the crown after succeeding in 1760.

George's biggest mistake was to lose the American colonies, which might well have been saved if he had handled the situation better. Nevertheless he presided over a vast expansion of British power and influence and held on to his throne at a time when the French Revolution was threatening many other monarchs. He was popular with his people, but went permanently insane in 1810. His son ruled as Prince Regent thereafter, leaving George to die a sad and lonely death in 1820.

George III (detail), Studio of Allan Ramsay, c.1767.

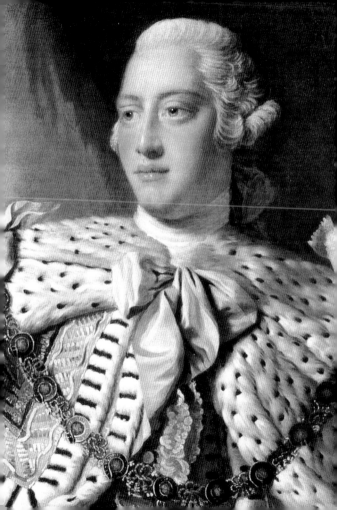

GEORGE IV

— ❖ —

reigned 1820-1830

Few kings had more potential for good than George IV. Stylish, witty and intelligent, he might have done great things if he hadn't also been idle, immoral and grossly extravagant. He undid much of the fine work done by his father and left the monarchy in a much shakier state than he found it.

Born in 1762, he was handsome when young, but rapidly lost his looks through too much good living. In 1785 he secretly married a Catholic, Mrs Fitzherbert, and ten years later was forced to marry Caroline of Brunswick, whom he despised. He tried to divorce Caroline when he became king in 1820. She responded by attempting to gatecrash his coronation at Westminster Abbey – a spectacle that did not impress the public. It was a relief for everyone when George died in 1830, leaving Brighton Pavilion as his most worthwhile memorial.

George IV (detail) after Sir Thomas Lawrence, 1815.

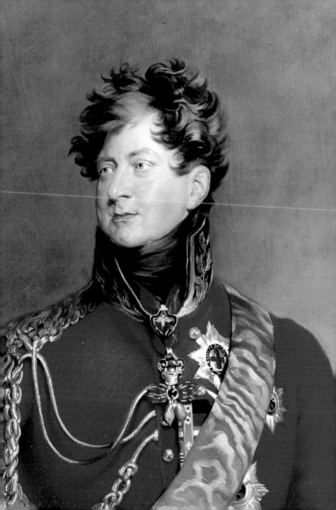

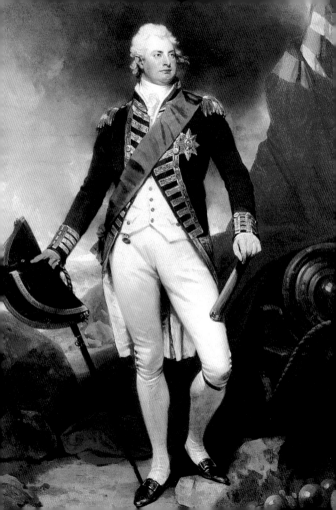

WILLIAM IV

reigned 1830-1837

As George III's younger son (born 1765), William never expected to become king. He was delighted to have the job thrust upon him when George IV died in 1830 without a legitimate heir. William had joined the Navy at thirteen, but was considered too stupid to take command of a ship. 'Who's a Silly Billy now?' he demanded, when the Privy Council knelt before him for the first time at his accession.

In fact, William's simplicity and lack of pretension greatly endeared him to his people after the excesses of George IV. He was a cheerful old cove who sometimes offered pedestrians a lift if he happened to be passing. He supported the reformers in the Great Reform crisis of 1832 and was thus the only monarch to keep his throne at a time when revolution was sweeping dynasties away all across Europe. He died in 1837.

William IV by Sir Martin Archer Shee, c.1800.

VICTORIA

— ❖ —

reigned 1837-1901

Victoria gave her name to the age she lived in. Born in 1819, she succeeded her uncle in 1837 and reigned first as Queen, then as Queen-Empress, for the rest of the century. During this time, more than a fifth of the earth's population and 40 per cent of its land-mass came under English domination – the greatest empire the world had ever known.

Victoria married Albert of Saxe-Coburg-Gotha in 1840. They had nine children, who in turn married into the other royal families of Europe, hoping thus to avert the disastrous wars of the past. Victoria's own marriage was very relaxed and cheerful. It was only after Albert died in 1861 that she earned a reputation for dourness. She survived him by forty years – a long and glorious reign that left her successors with a difficult act to follow.

Victoria (detail) by Sir George Hayter, 1863.

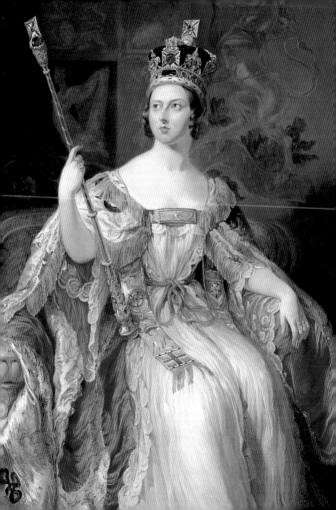

EDWARD VII

dward was fifty-nine and a grandfather when he succeeded Queen Victoria in 1901. He had spent all his life in his mother's shadow, waiting for her to die so that he could take his place as king.

Unfortunately, his mother had a poor opinion of him and never allowed him to share her work. With nothing else to do, he wasted his time instead, eating too much, smoking too much and chasing women. He was involved in a gambling scandal and a widely publicized divorce case. But all of this changed when Edward became king. Far from making a mess of it, as Queen Victoria had predicted, he was a huge success. He travelled the world on goodwill visits, promoted the 'entente cordiale' with France, and did his best to head off the approaching war with Germany. He died in 1910.

Edward VII by Luke Fildes, 1902.

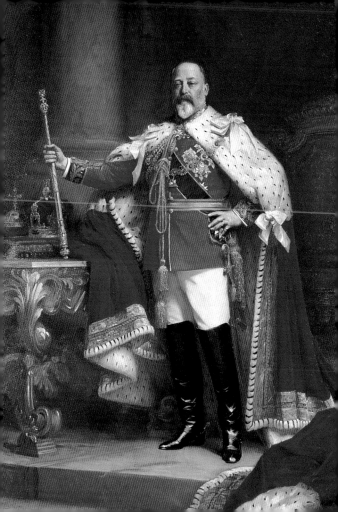

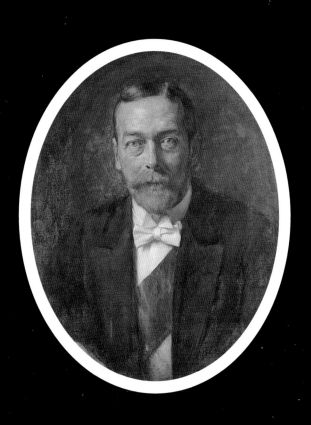

GEORGE V

— ⁘ —

reigned 1910-1936

Unlike his father, George (born 1865) was rather a dull man. He had none of Edward's vices, but remained happily married all his life and liked nothing better than to sit in his study and look at his stamps. Yet he was highly conscientious and presided over the British Empire at a time of immense social and political change.

He succeeded in 1910. His reign saw the First World War, the Russian Revolution, the Irish troubles, votes for women, the General Strike, the Depression, the rise of Hitler and the first radio broadcast by a reigning monarch. George's tours during the First World War brought him into contact with ordinary men and women in a way that hadn't been seen in England for centuries. He was always very conscious of his duty to his people and was much missed by them when he died in 1936.

George V (detail) by Lance Calkin, c.1914.

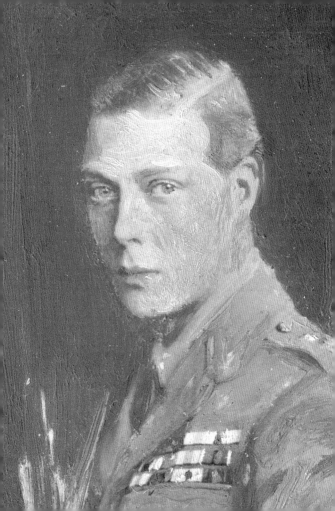

EDWARD VIII

❖

reigned 1936

Edward was a disastrous king. Born in 1894, he grew up shallow and self-indulgent and was never able to match his father's conscientiousness and attention to duty, although he tried his best. Edward served in the First World War and shared the general euphoria when it was over. He loved the Jazz Age and was a keen follower of American fashions. He might have made a very modern king if he hadn't fallen in love with an American divorcee, Mrs Simpson. Divorce was frowned on in those days and Mrs Simpson was in any case quite unsuited to be queen. When Edward succeeded in 1936, he immediately provoked a constitutional crisis by wanting to marry her. Forced to choose between her and the throne, he chose Mrs Simpson and abdicated the same year, dying in 1972. The English never forgave him for his weakness.

Edward, Duke of Windsor, (detail) by Reginald Grenville Eves, c.1920.

GEORGE VI

reigned 1936-1952

George was born in 1895, but never wanted to be king. Shy, and with a terrible stammer, he was appalled when his brother Edward abdicated in 1936. He suddenly found himself head of the British Empire at a time when another war with Germany seemed inevitable.

The war duly broke out in 1939. A year later the Germans blitzed London, destroying much of the East End. Buckingham Palace was bombed too and George set a fine example to his people, sharing their discomforts and refusing to send his family to safety in Canada, as he could have done. Throughout the war he lived like everyone else and insisted on eating the same meagre rations as his people did. By the time the war was over, he had restored all the prestige to the monarchy that his brother had lost. But the strain ruined his health and he went to an early grave in 1952.

George VI (detail) by Sir Gerald Kelly, c.1939.

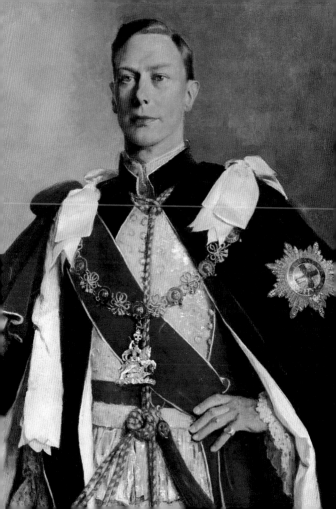

ELIZABETH II

reigned 1952-

lizabeth is directly descended from William I, the Norman adventurer who conquered England over 900 years ago. She is also descended from most, though not all, of the monarchs in-between. Born in 1926, she succeeded her father in 1952.

England was a world power when she inherited the throne, but has been losing its way ever since. Its empire has gone and much of its economic status as well. Respect for the monarchy too has declined in recent years. Elizabeth herself has always led a blameless life, but the antics of some of her family have led to a widespread questioning of the monarchy's continued relevance and a desire by some for a republic. Yet Elizabeth's ancestors have been in far worse situations before – and the monarchy has always survived.

Elizabeth II (detail) by Michael Leonard, 1985-6.

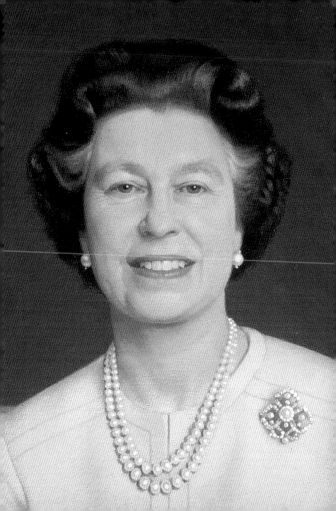